Christmas Dogs and Puppies Coloring Book

By Mindful Coloring Books

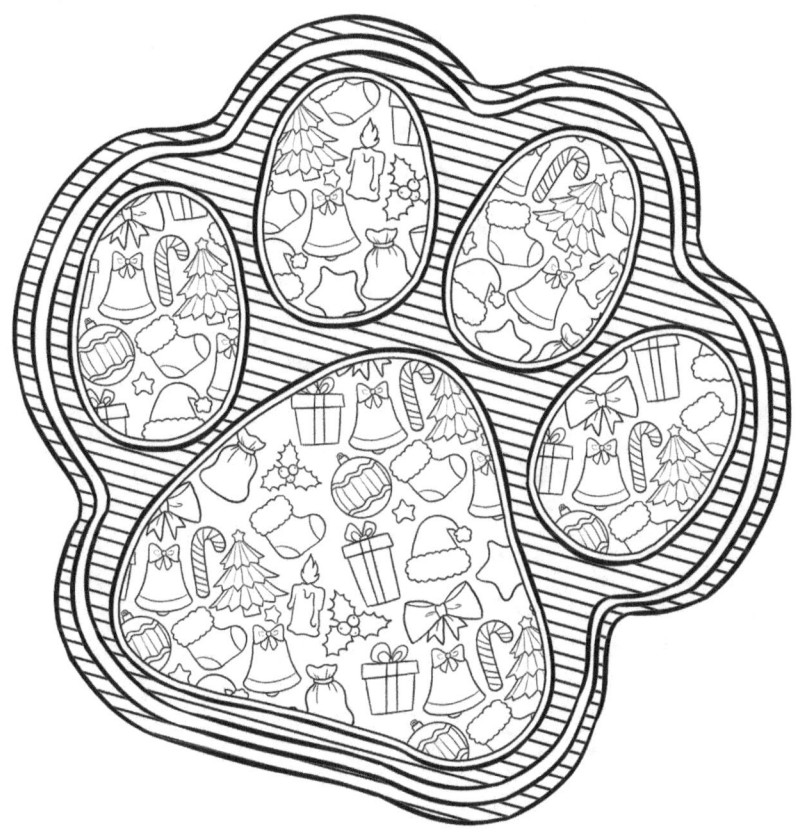

Copyright © 2017 by Mindful Coloring Books

All rights reserved. No part of this publication may be reproduced, distributed, or transmitted in any form or by any means, including photocopying, recording, or other electronic or mechanical methods.

Coloring Tips

~ Sometimes what you think the color will look like and what it will actually look like are very different. Use the color test page.

~ Don't press too hard. Start out coloring lightly and you can always go back and make it darker.

~ Keep your pencil tips sharp so you can get into all the intricate spaces.

~ Using markers? Place a scrap piece of paper behind the page you are coloring. Pages in this book are only printed on one side but there is still the risk of bleed through to the next page.

~ Try different coloring utensils marketed for adults. It is fun and quality can vary greatly.

COLOR TEST PAGE

COLOR TEST PAGE

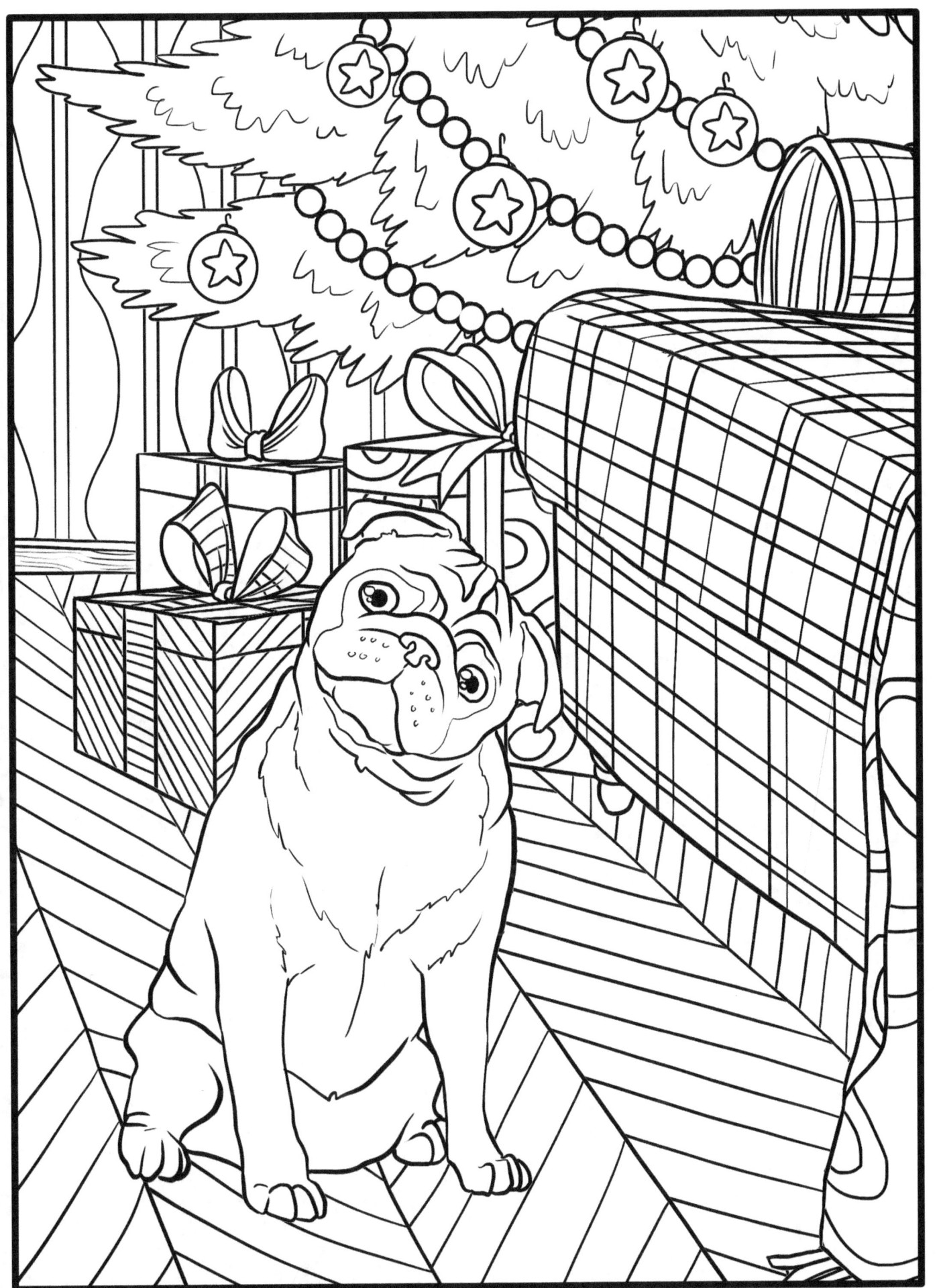

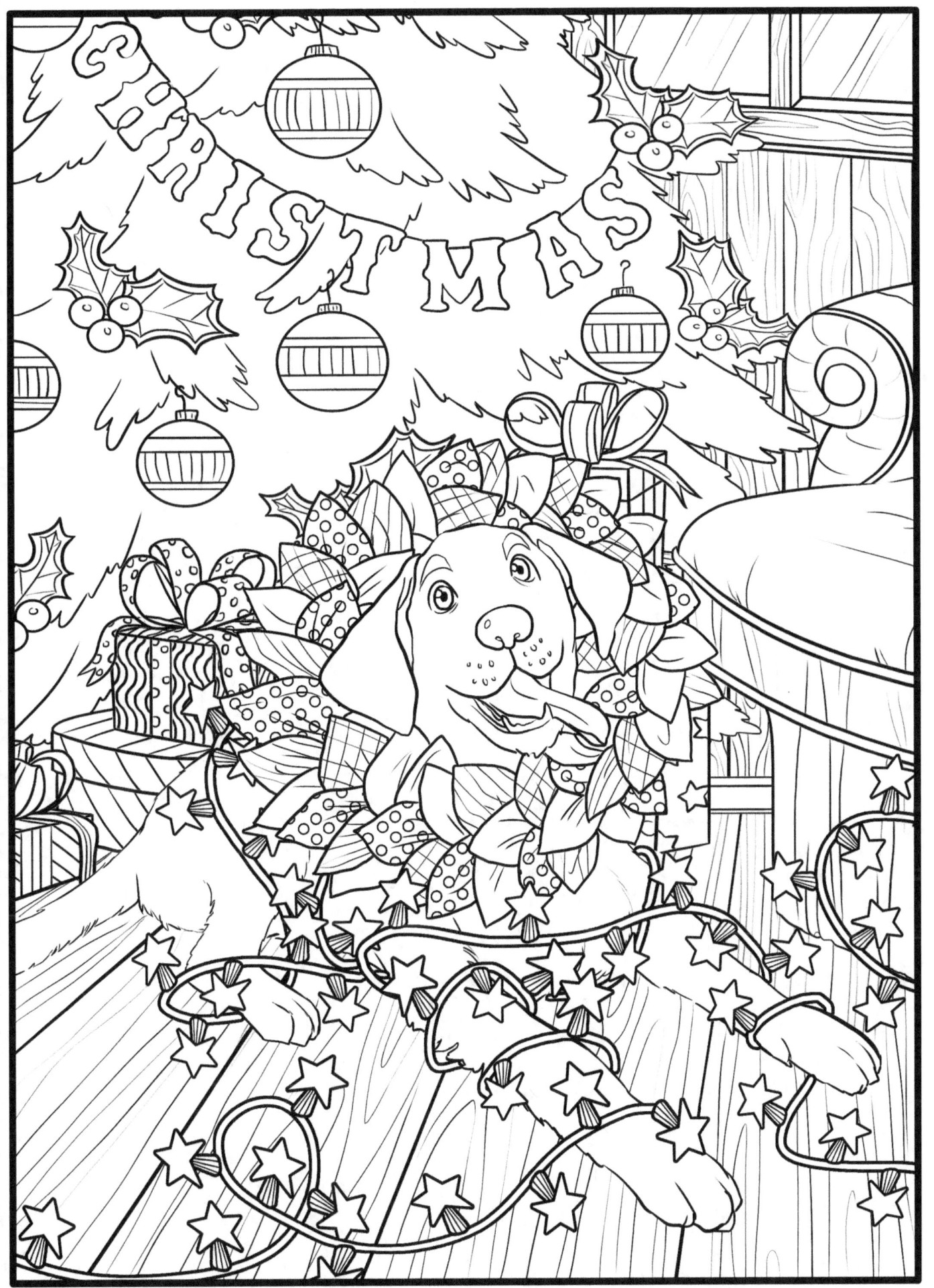

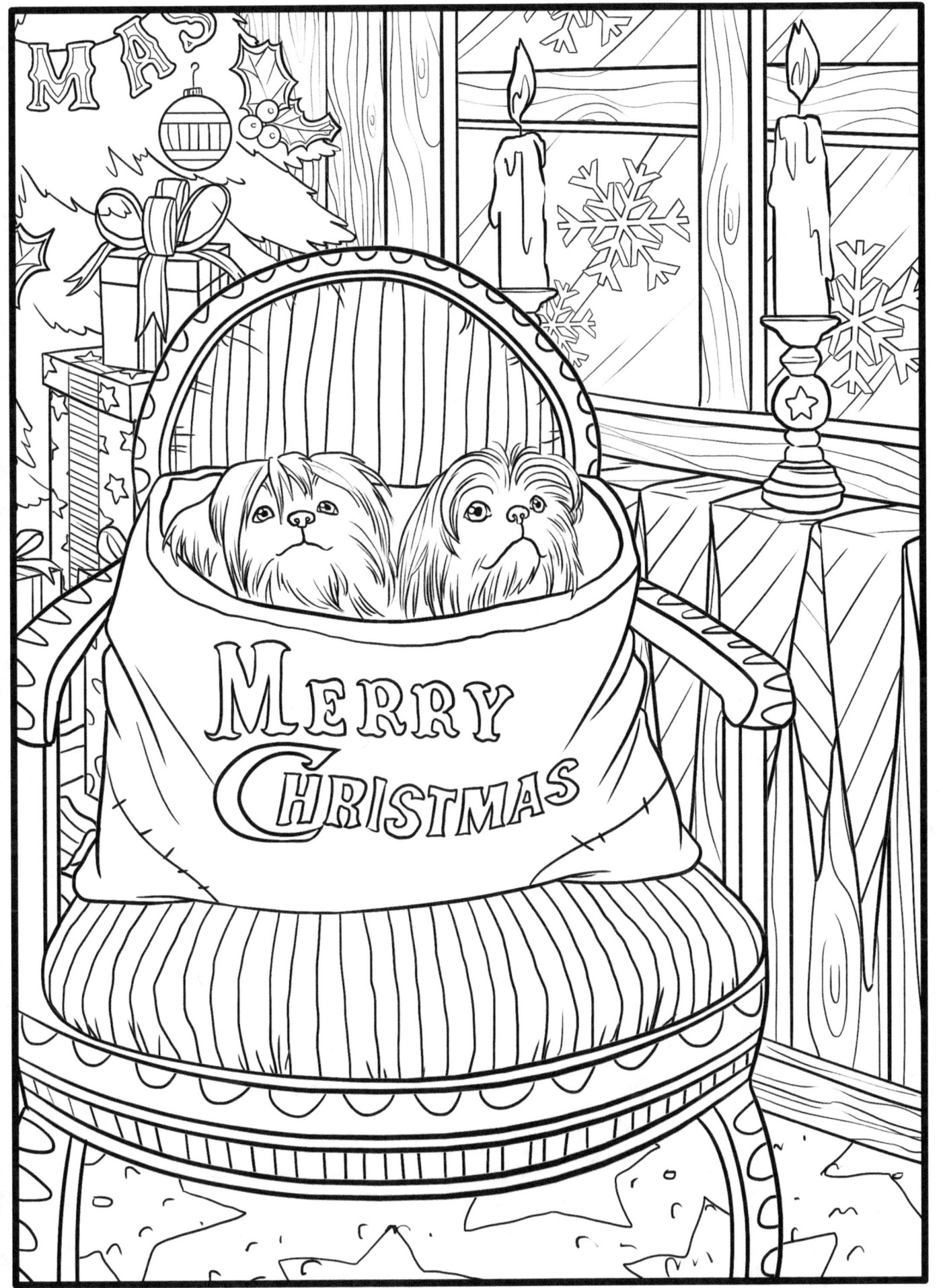

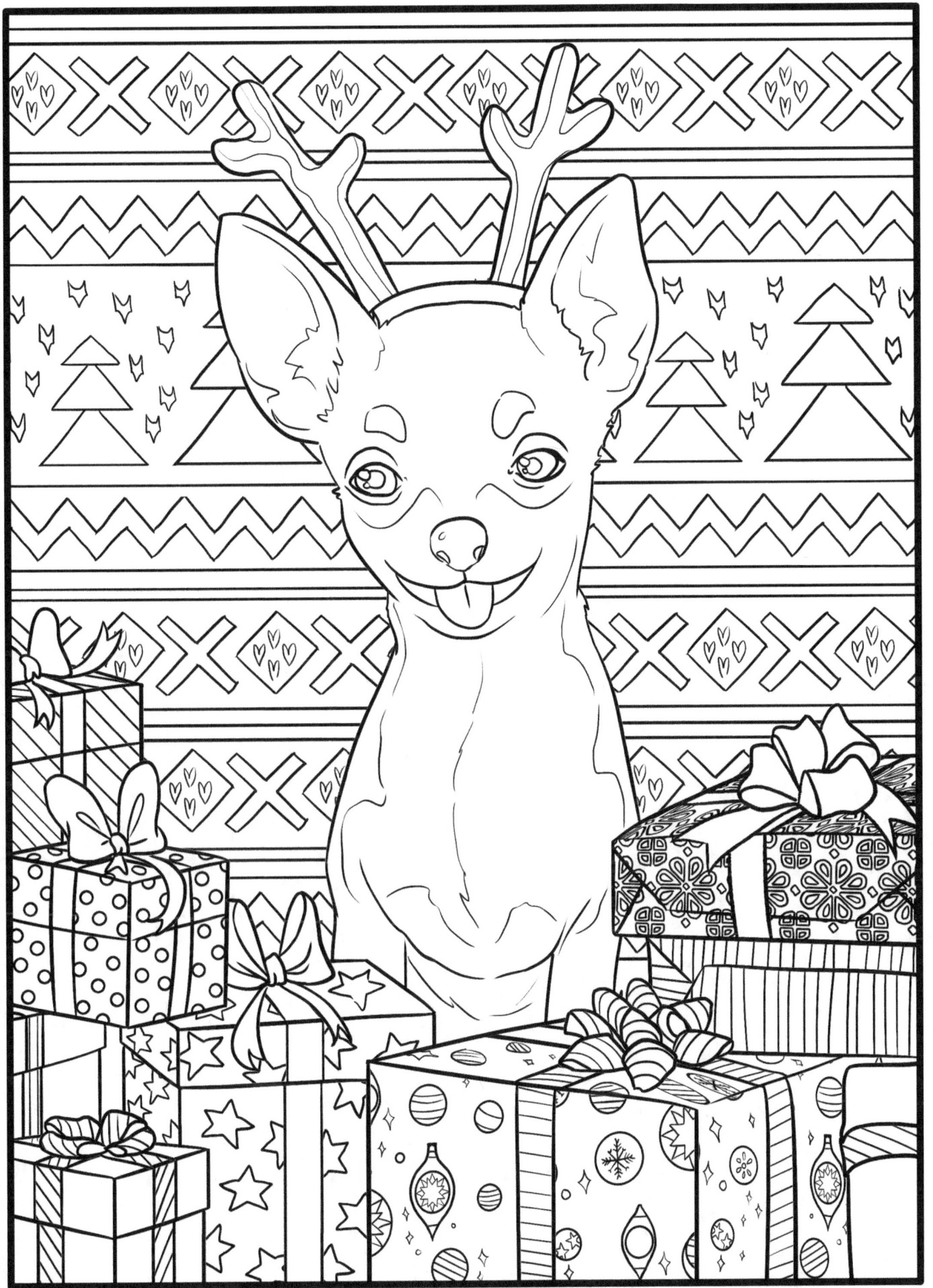

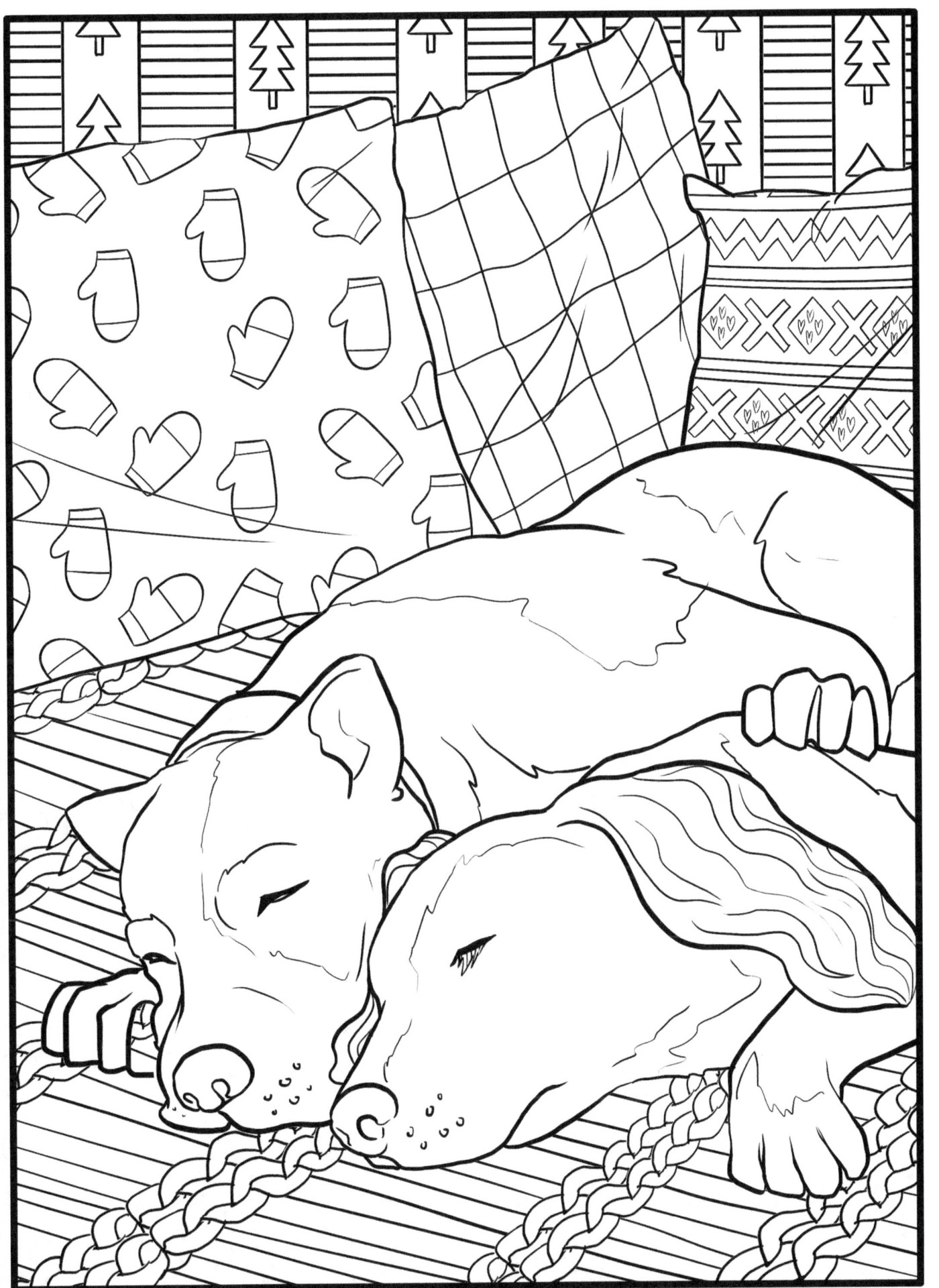

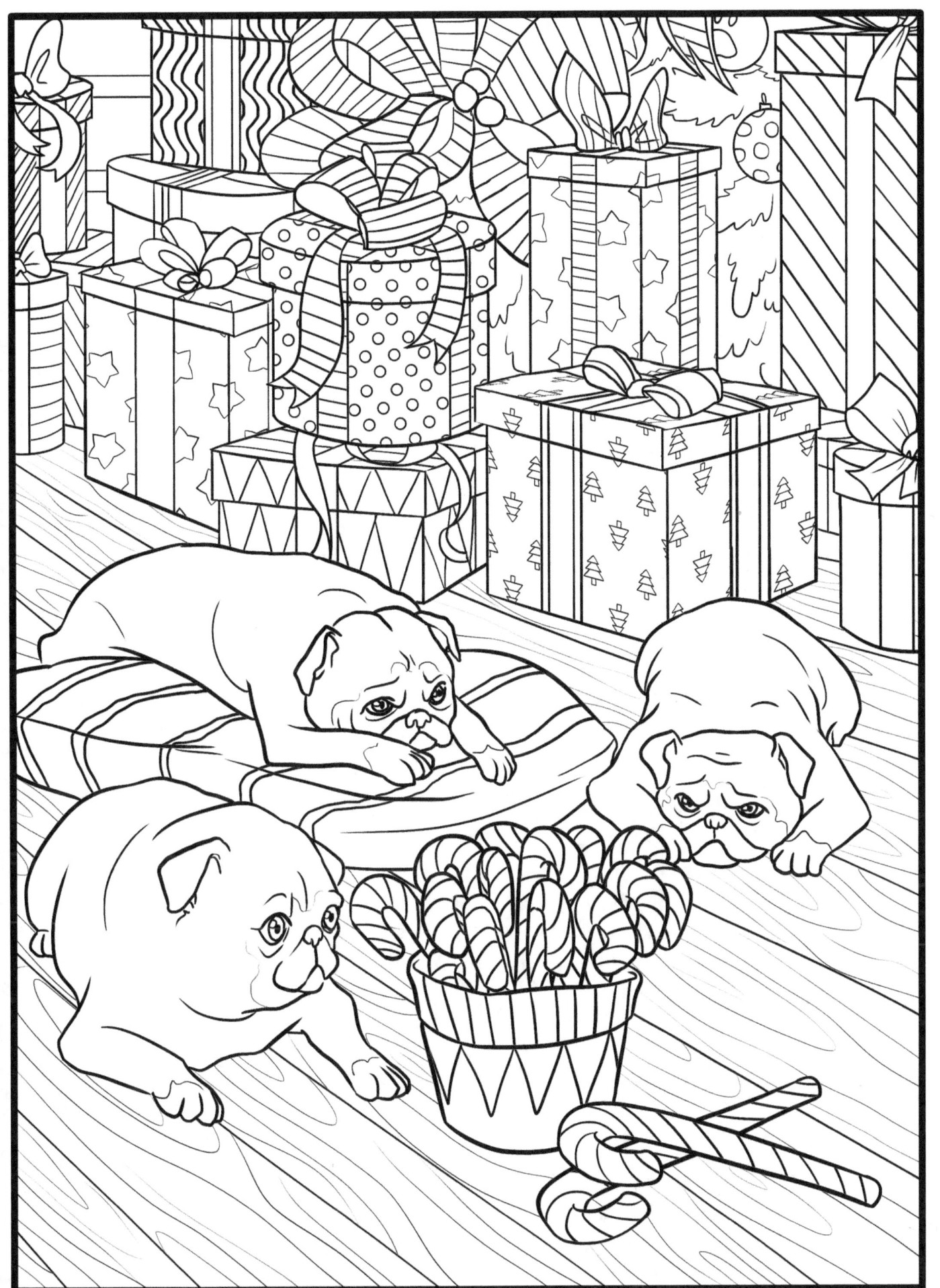

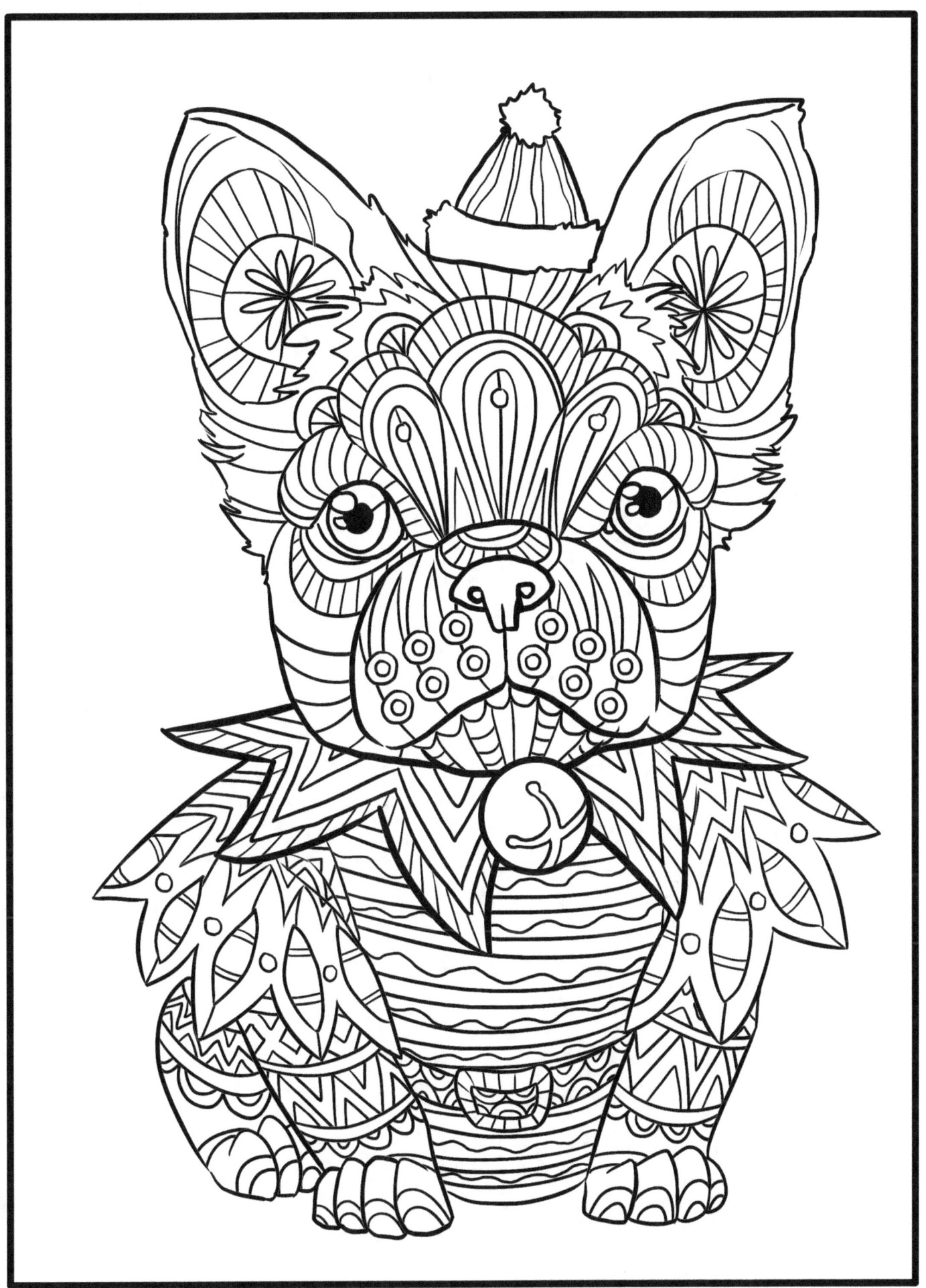

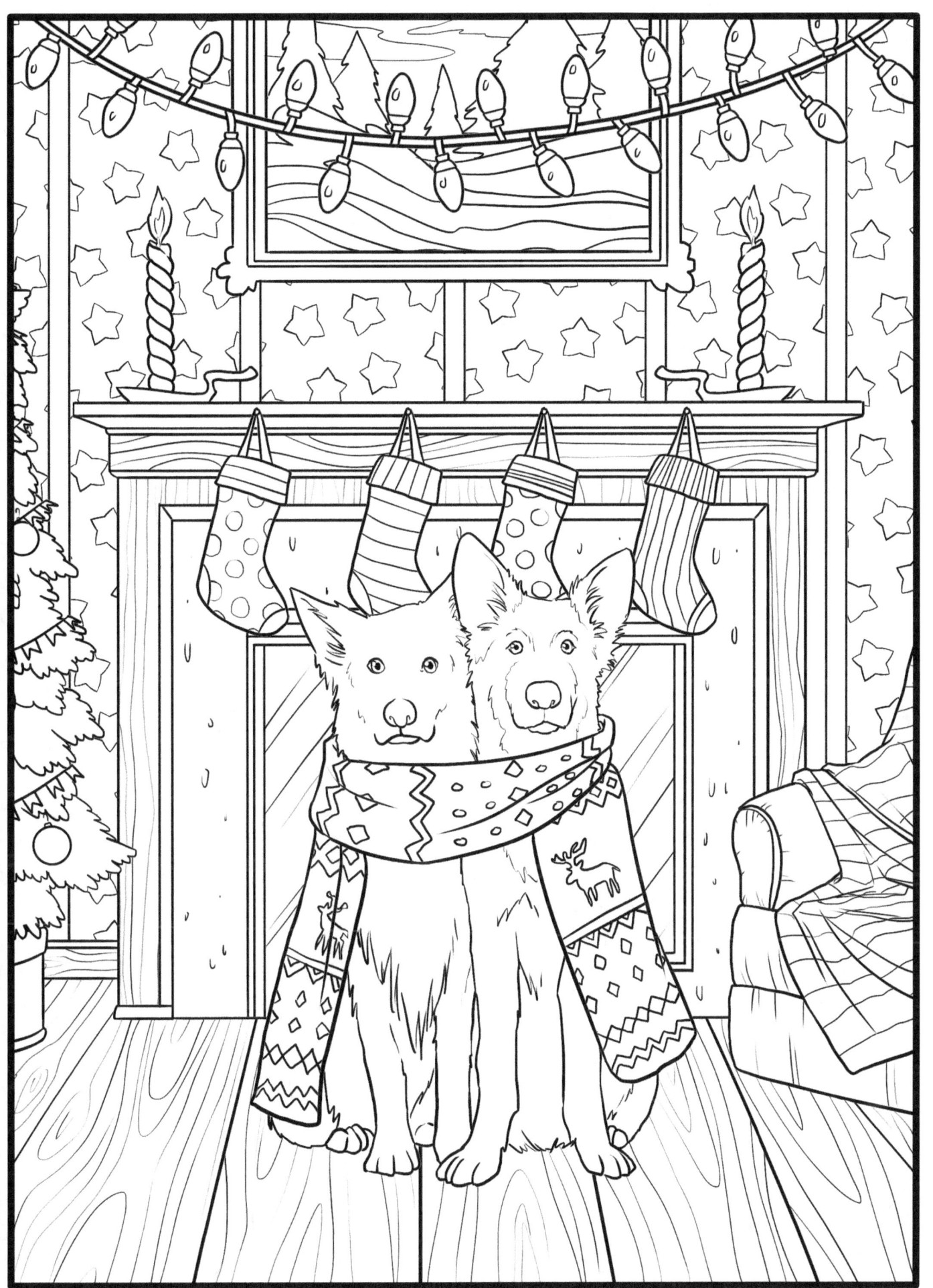

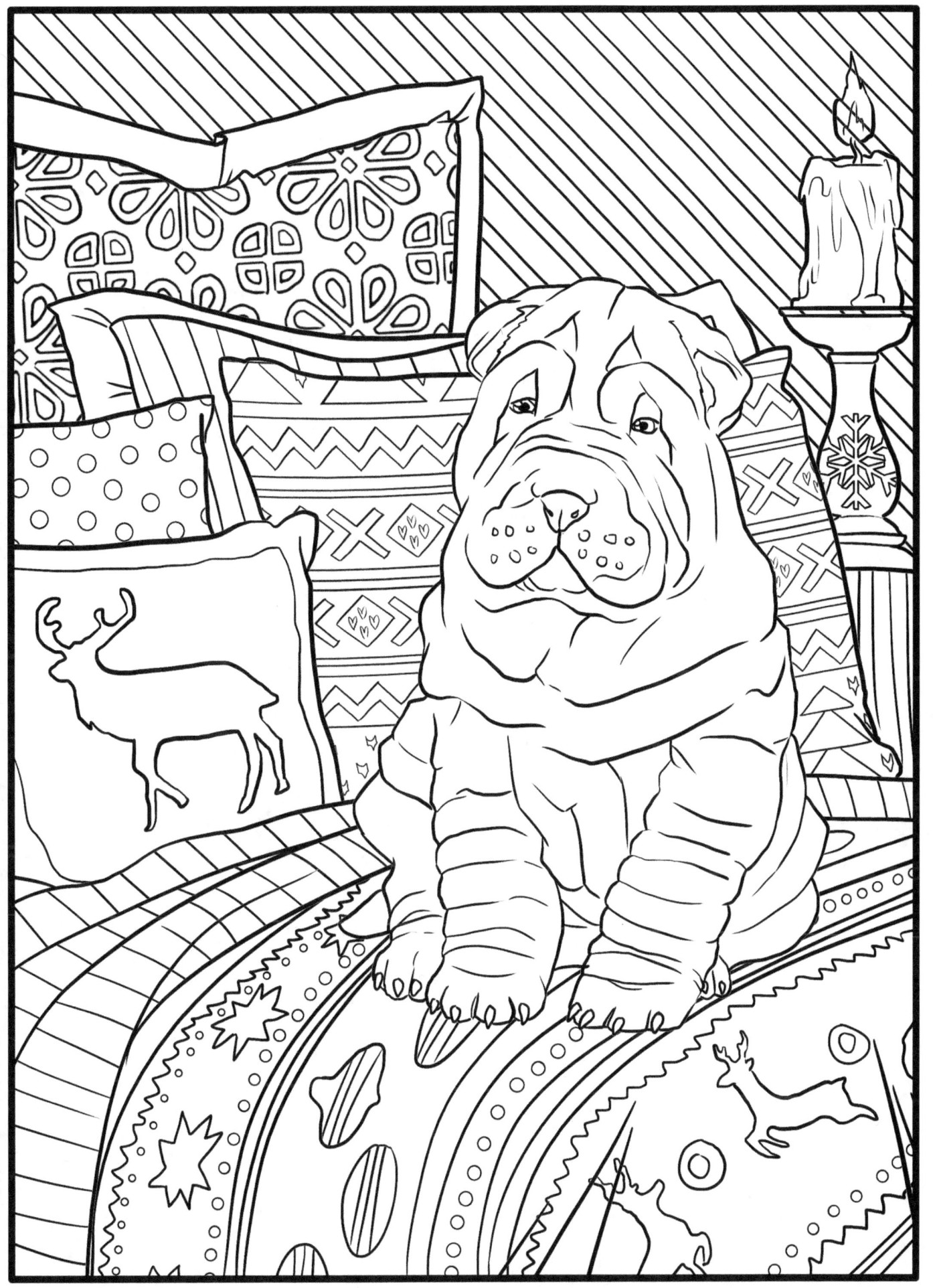

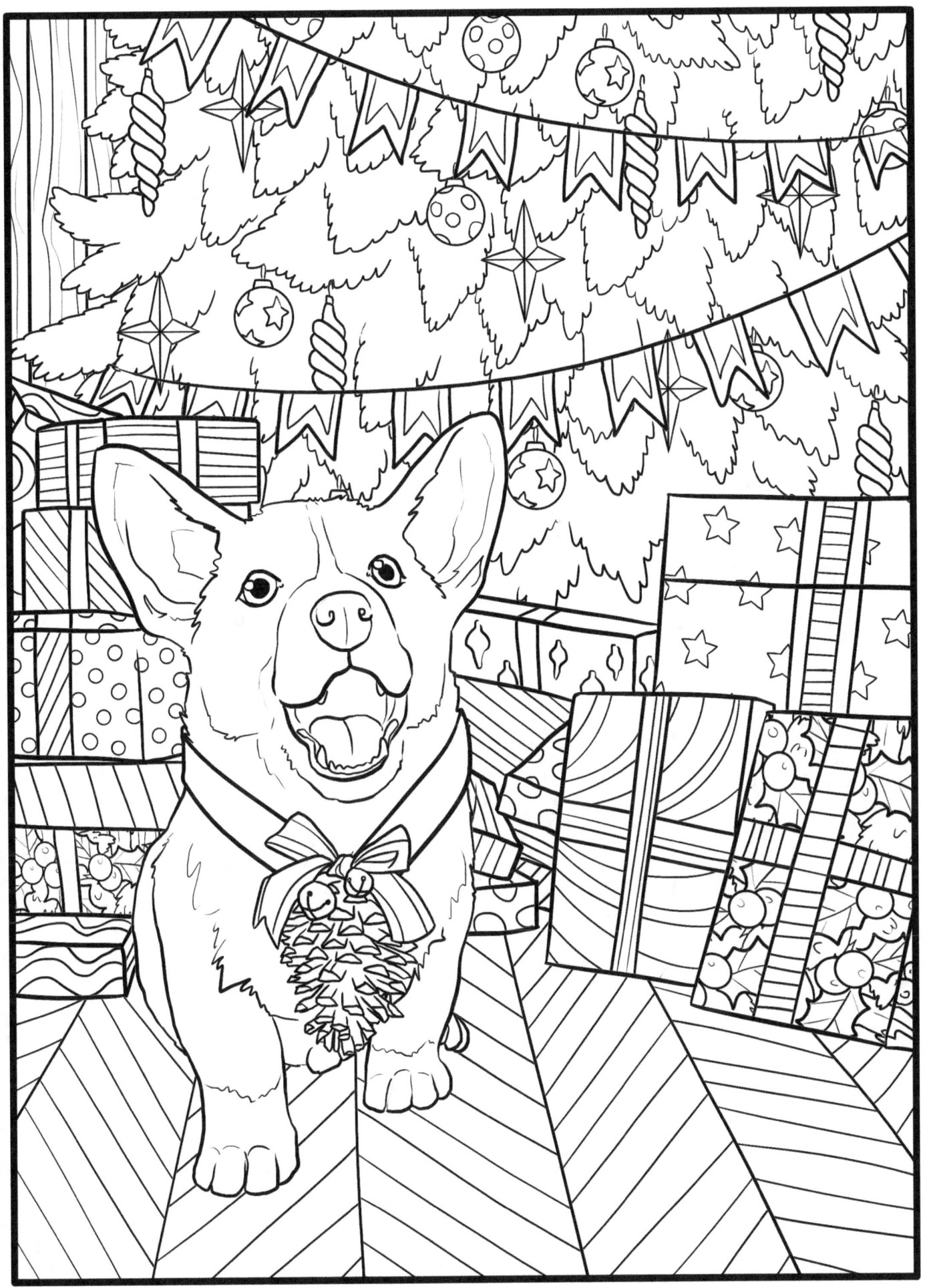

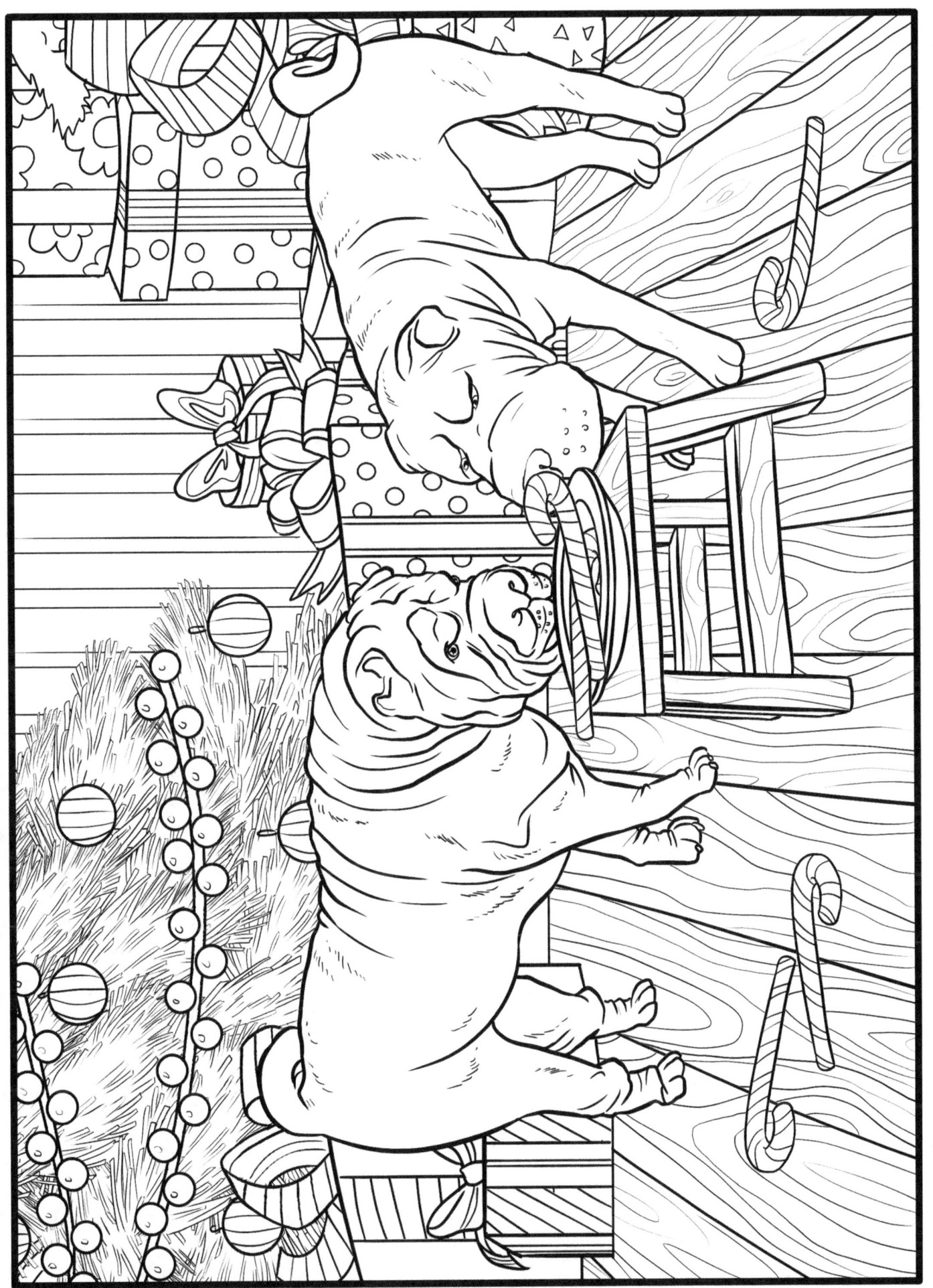

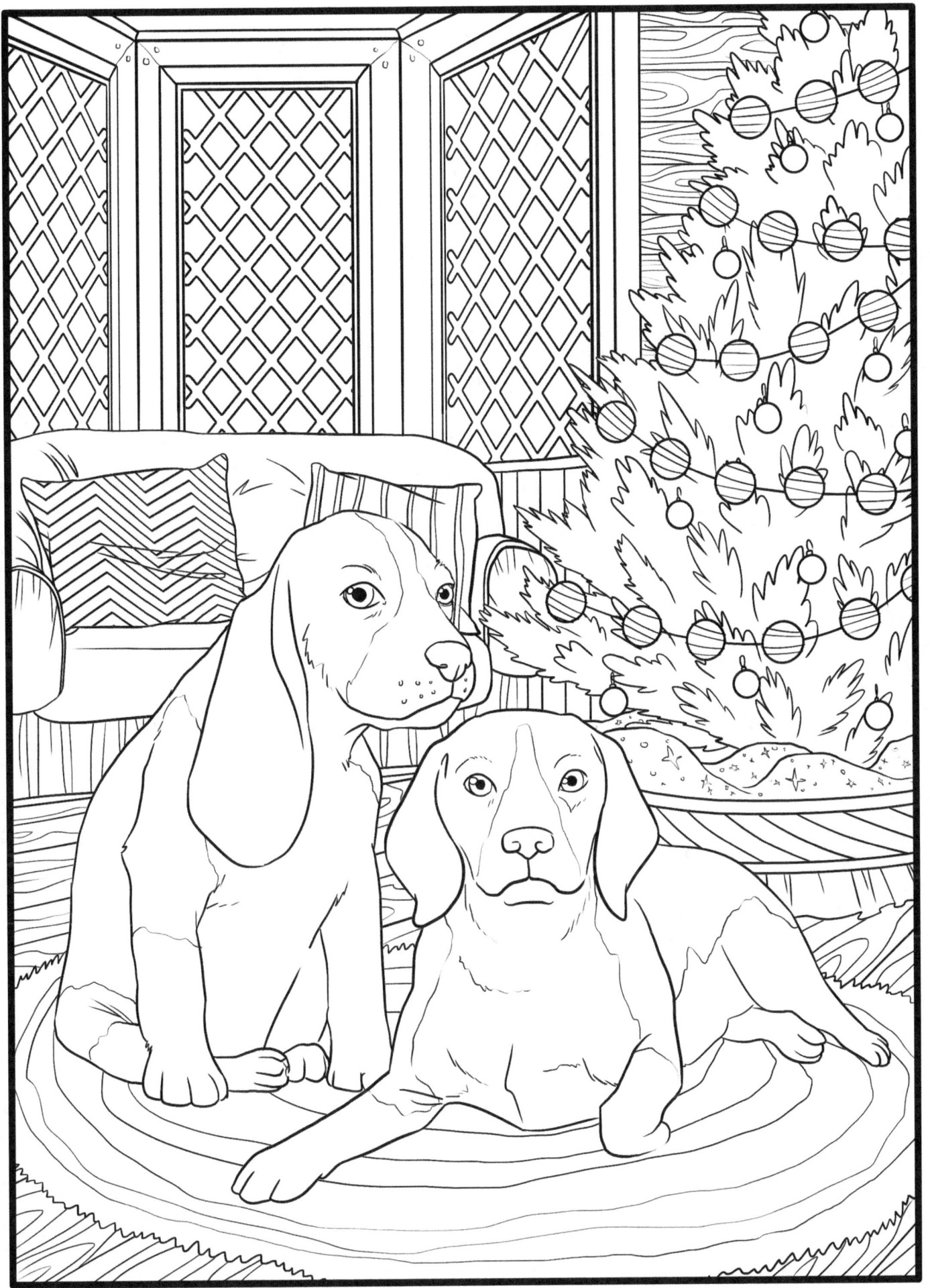

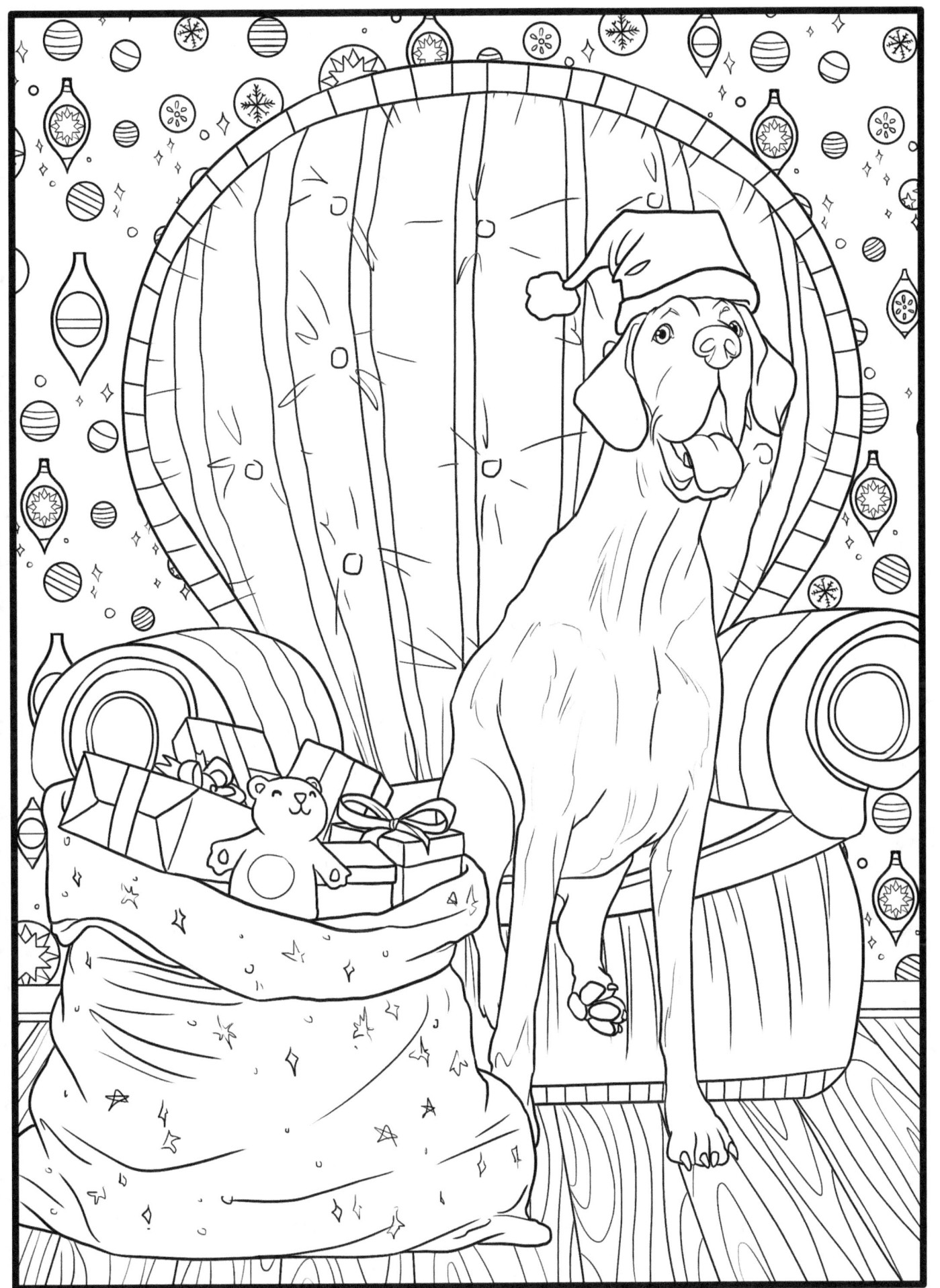

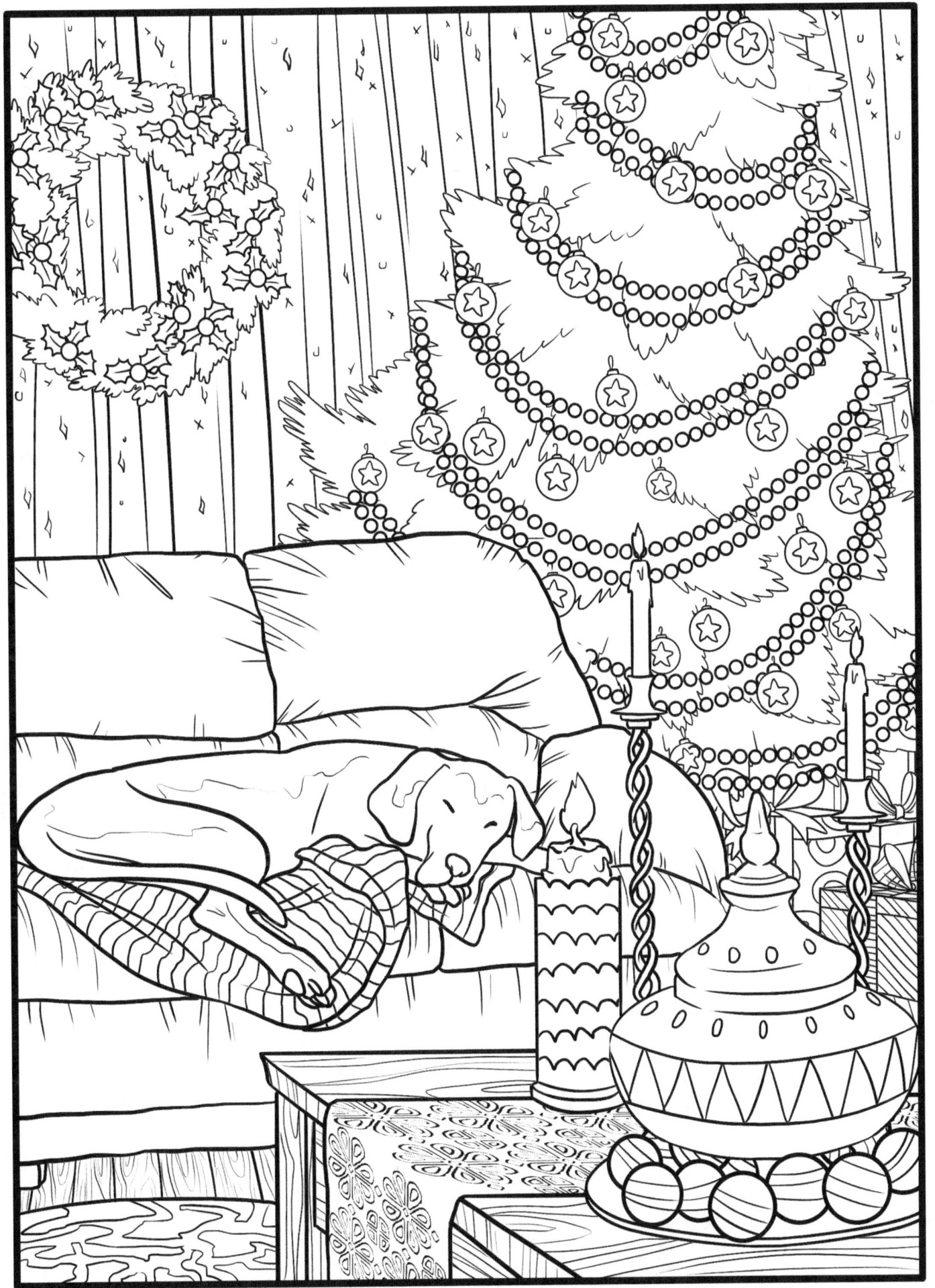

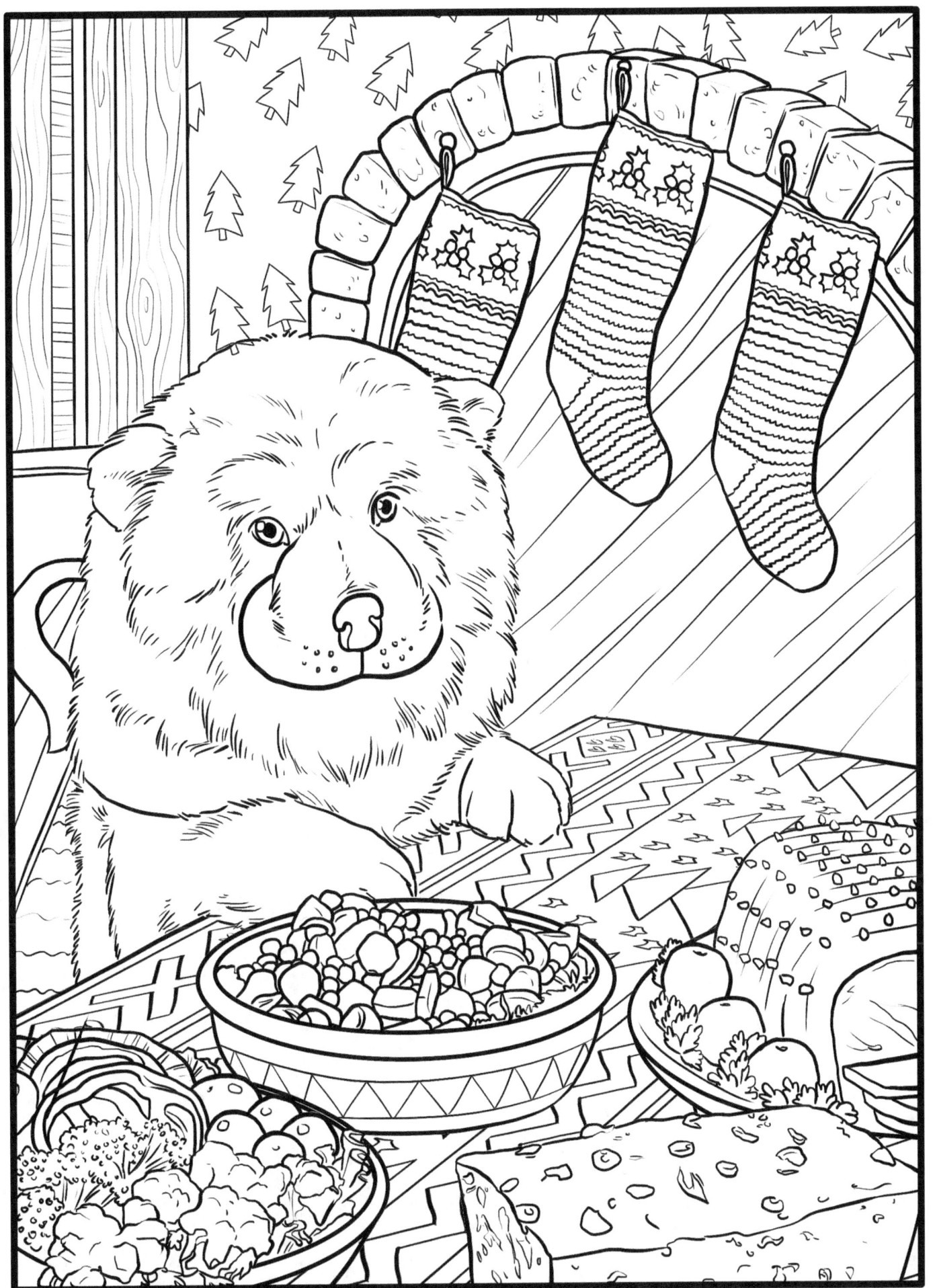

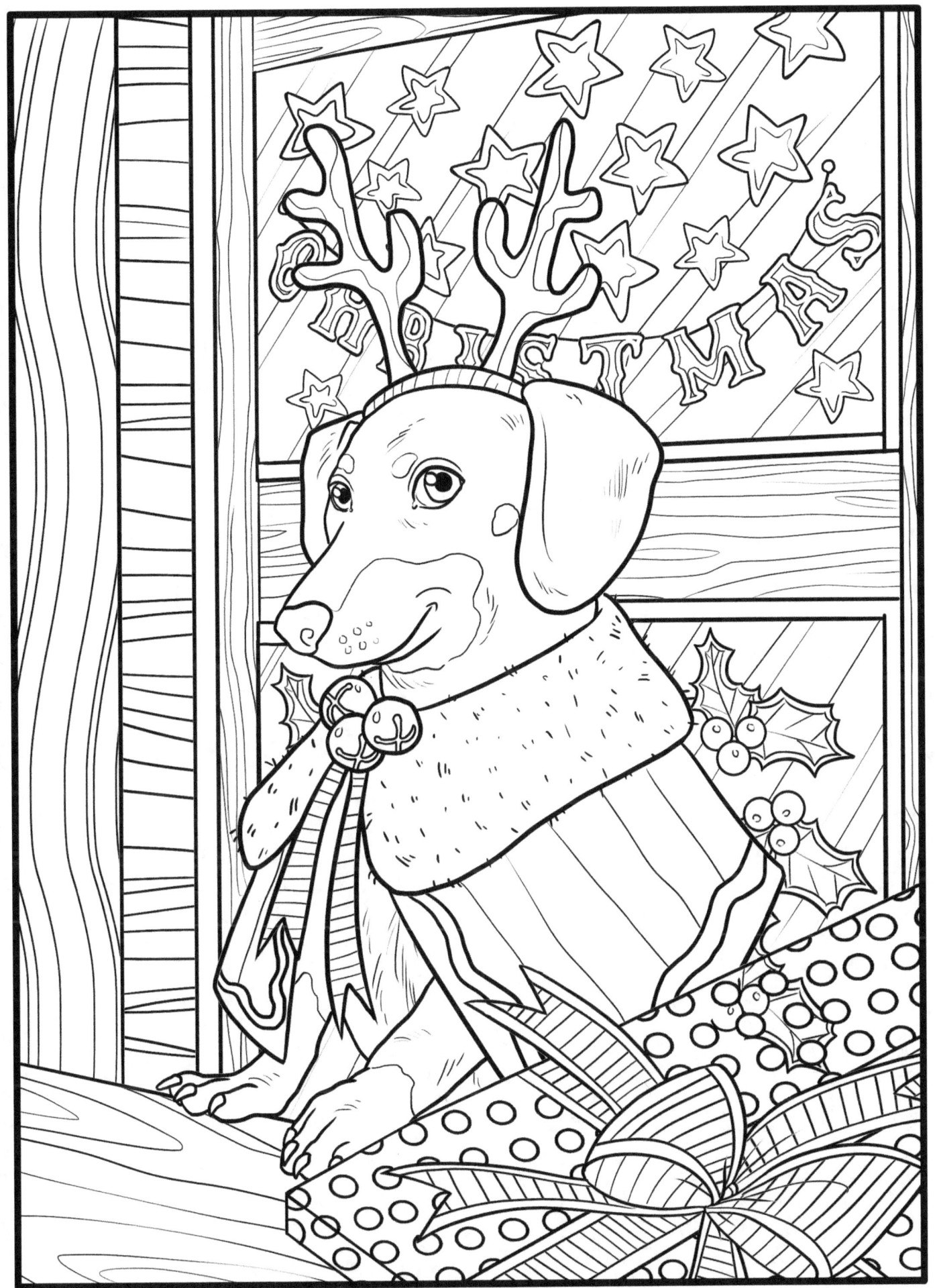

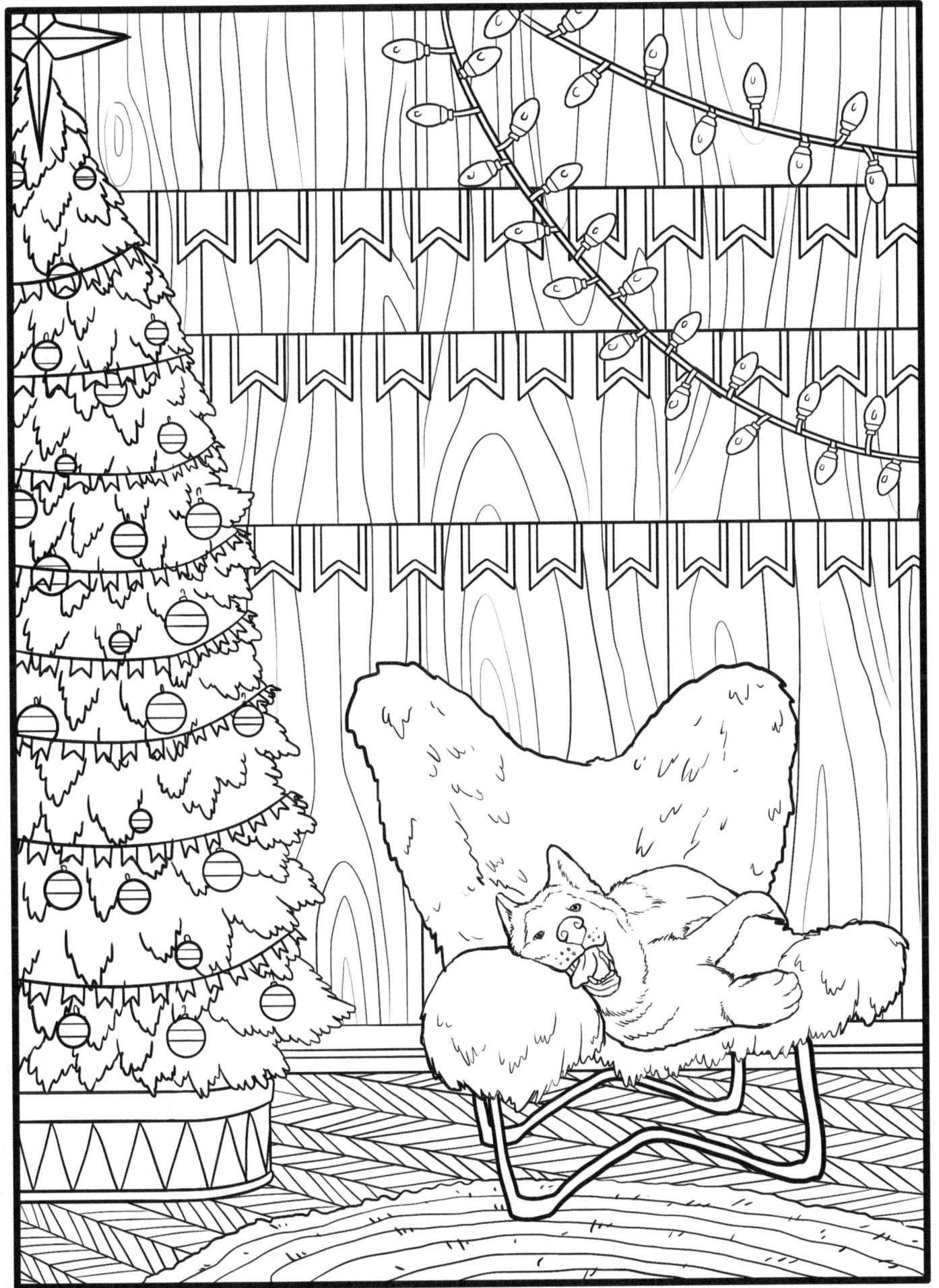

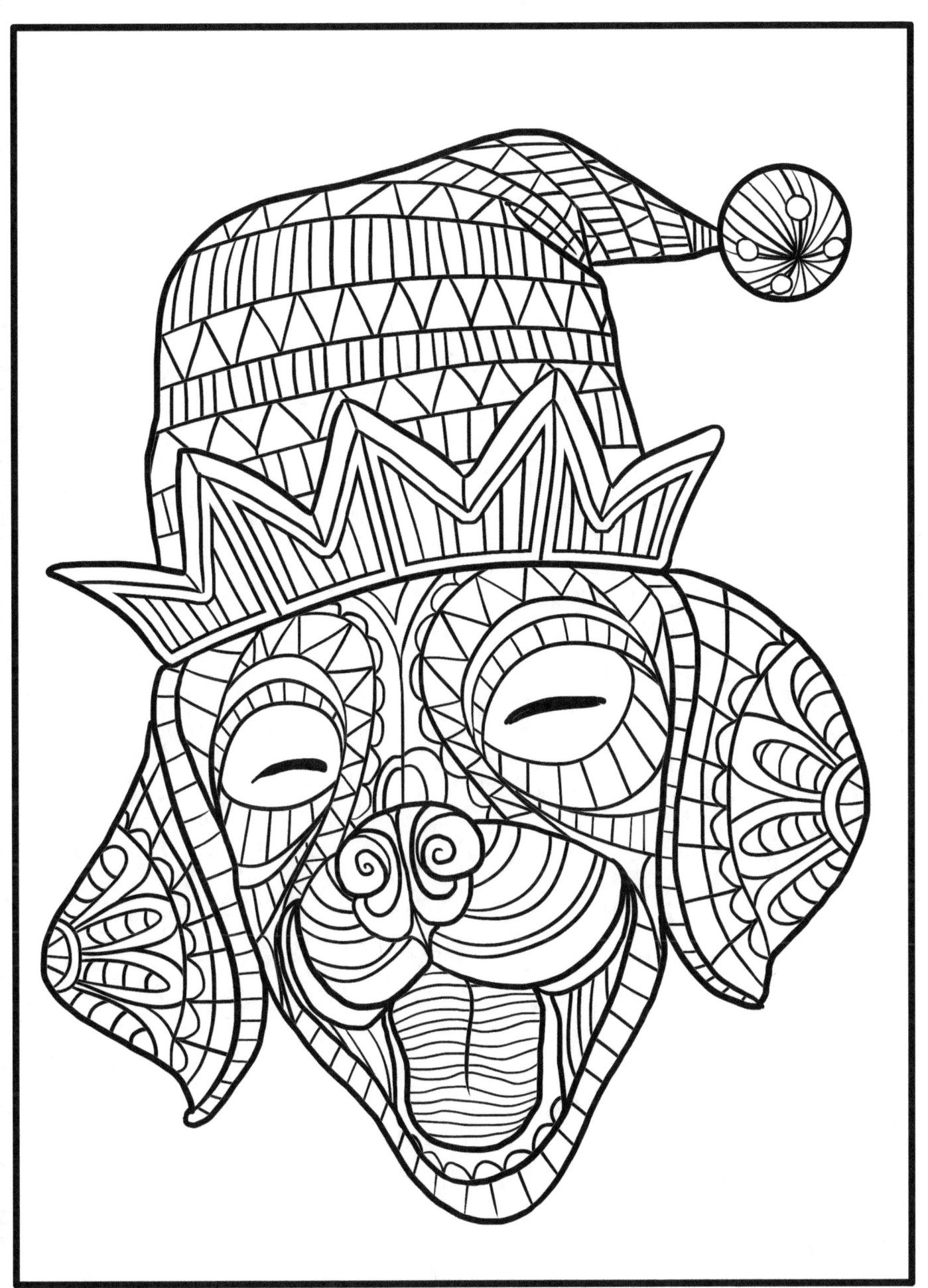

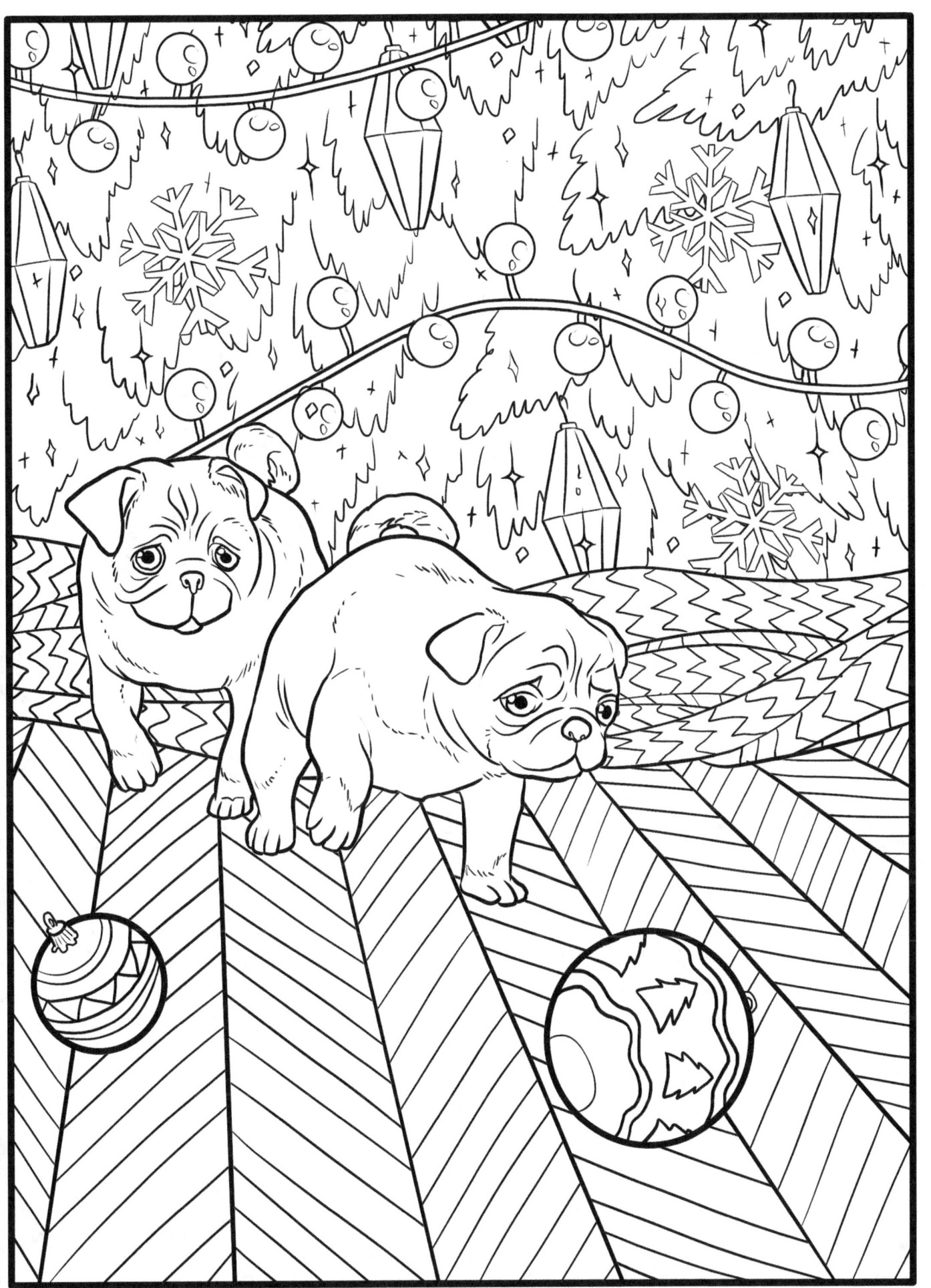

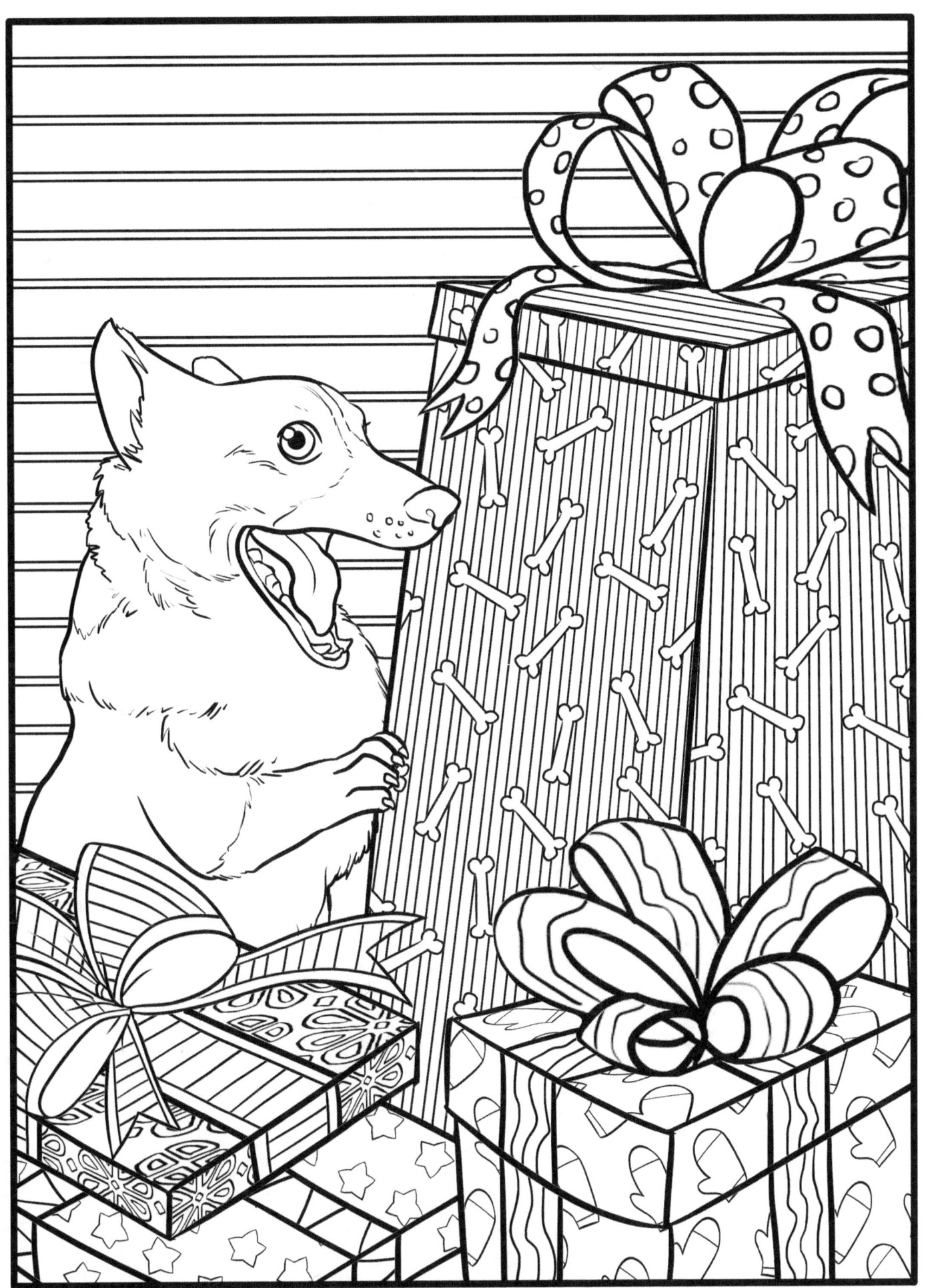

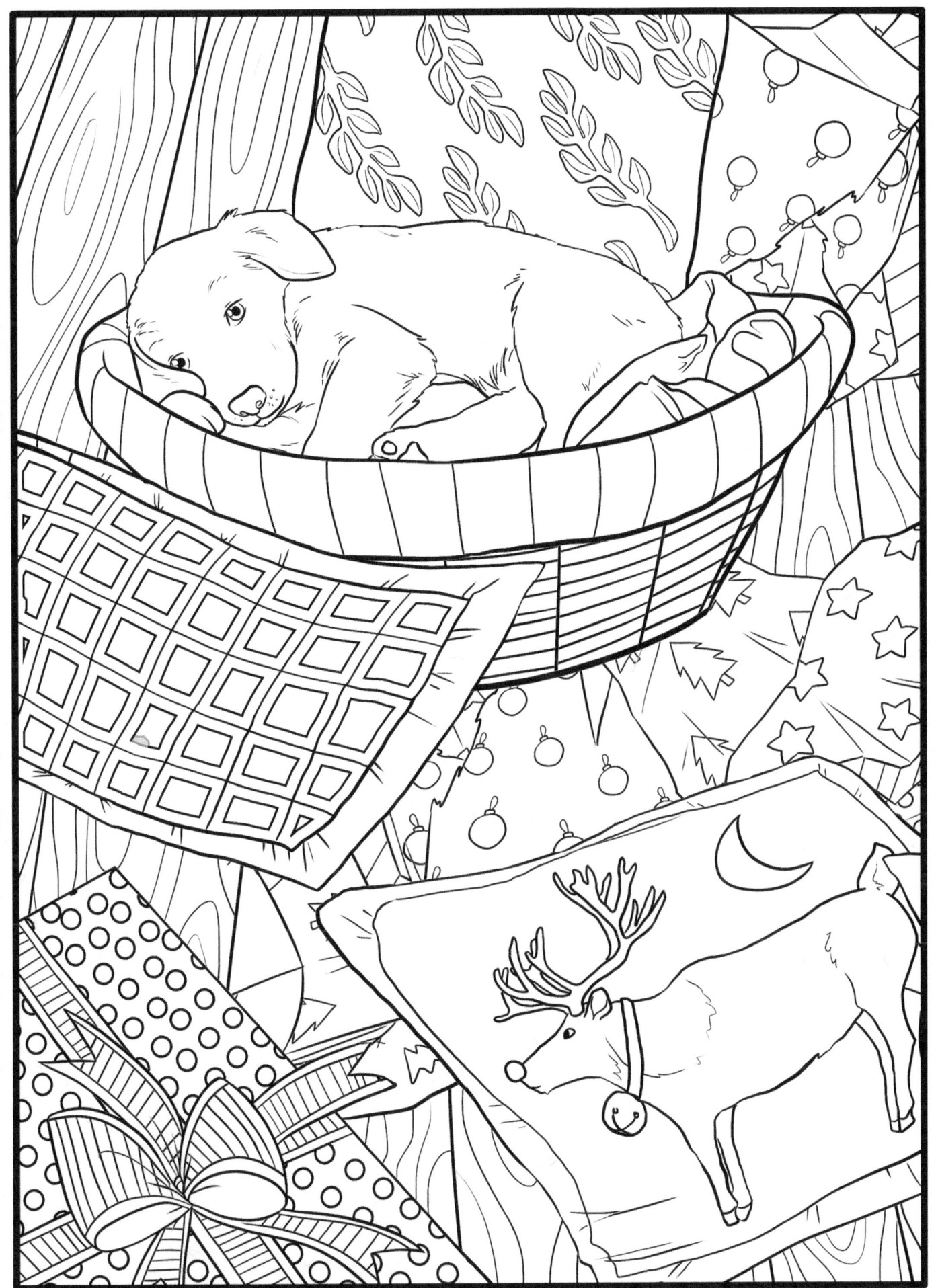

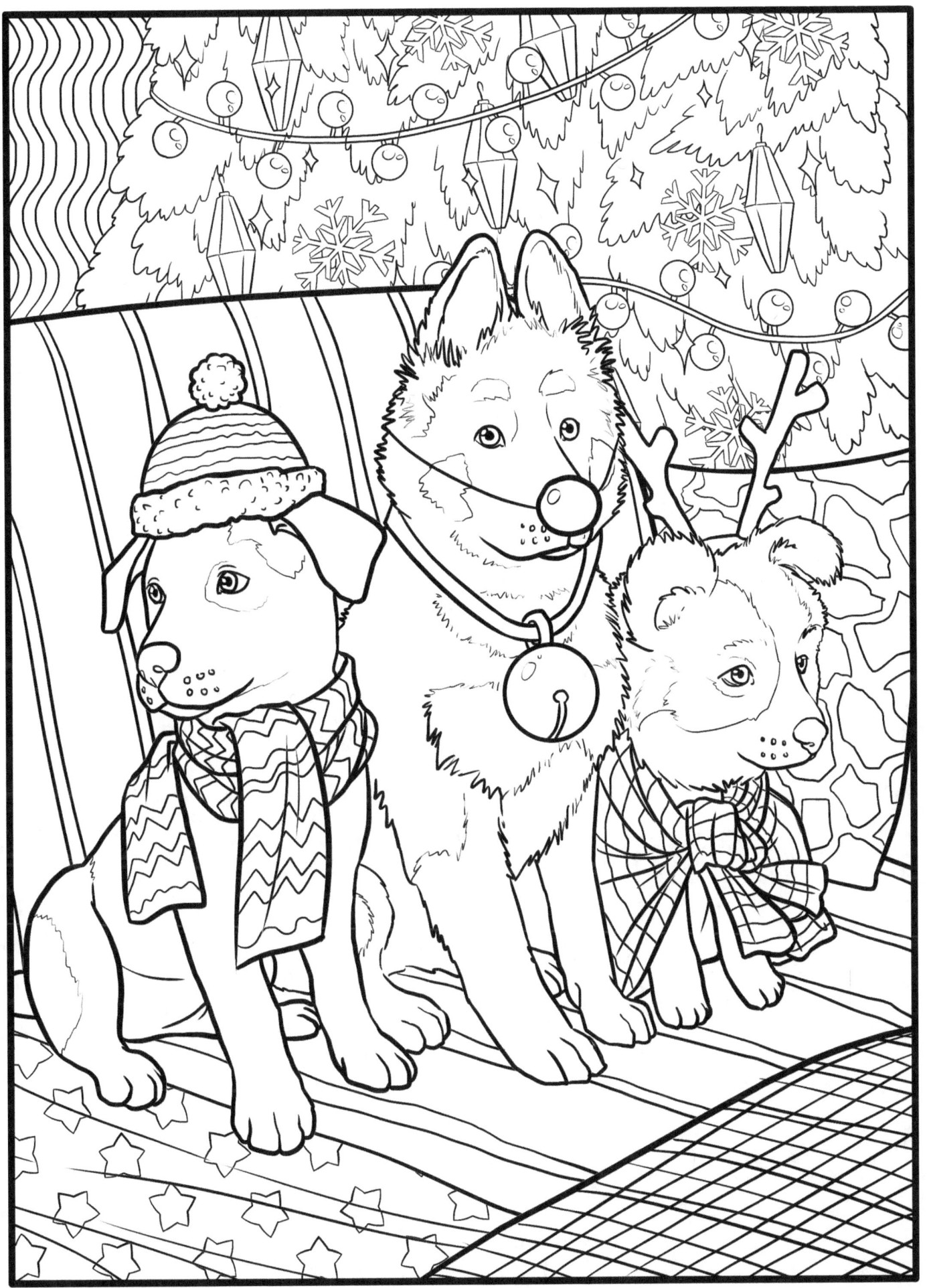

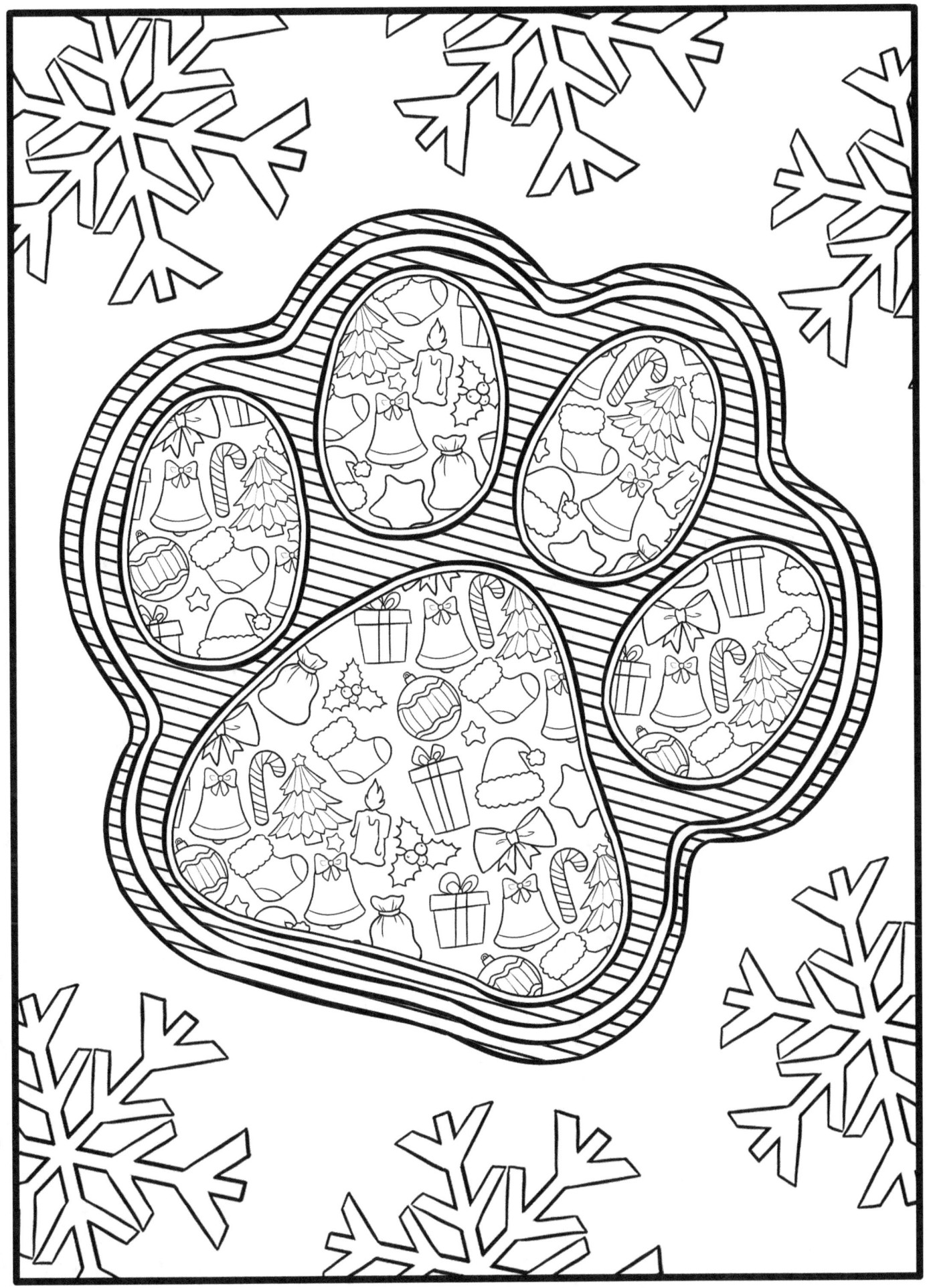

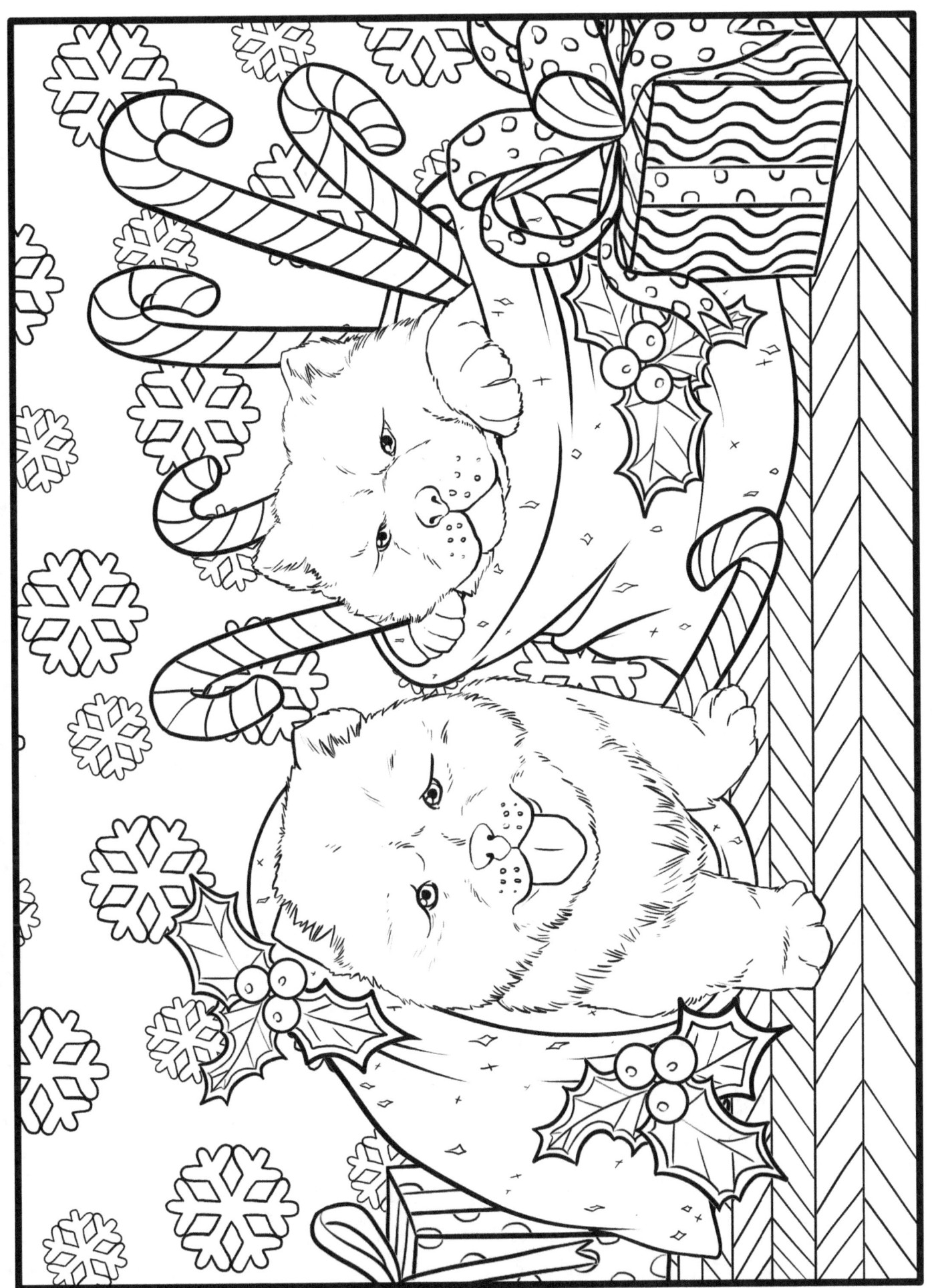

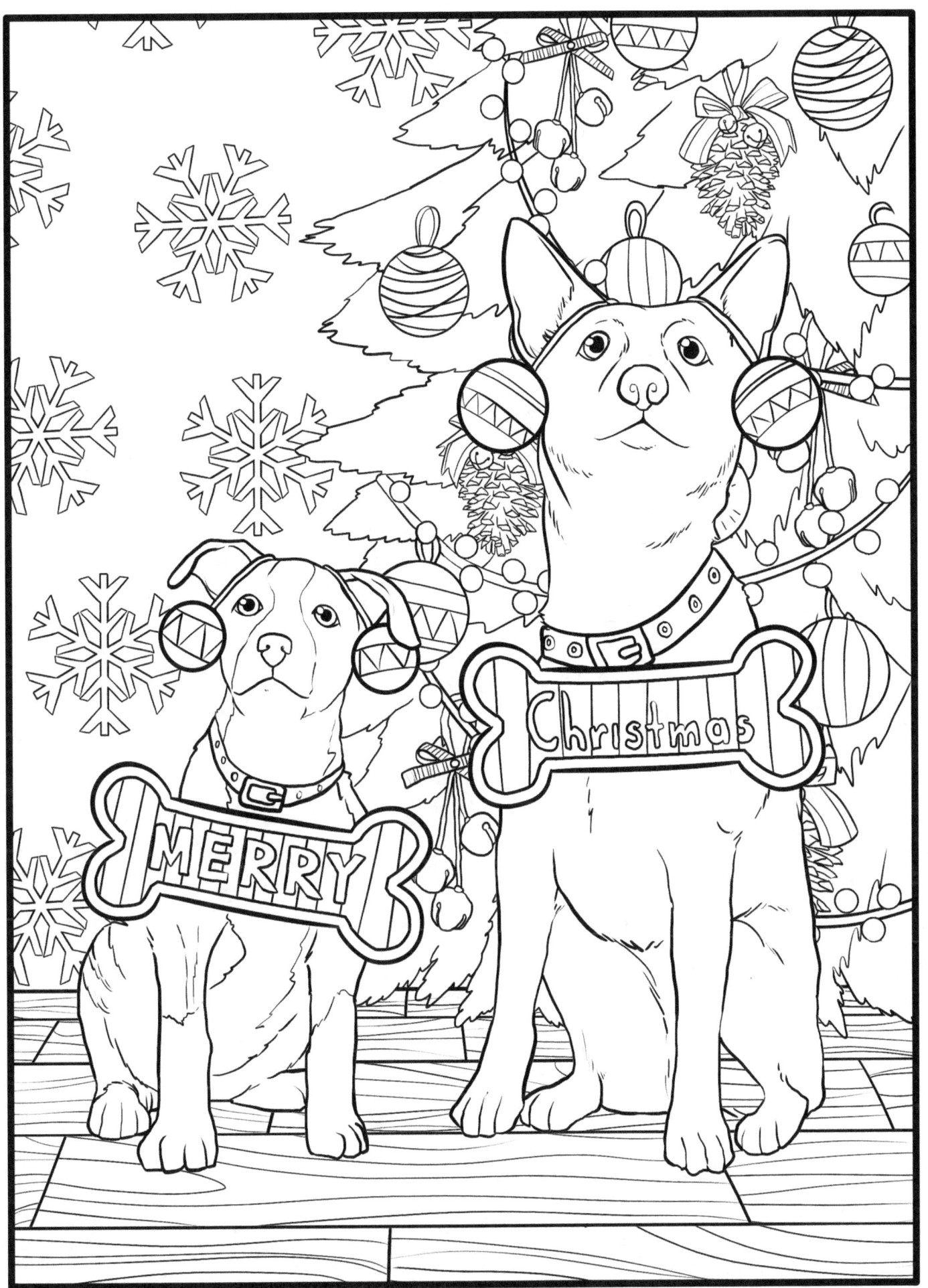

Leave us a review on Amazon!

Mindful Coloring Books:

Coloring books for adults
Coloring books for kids
Journals
Notebooks
Planners

Check out
Mindful Coloring Books

www.mindfulcoloringfun.com

amazon.com/author/mindfulcoloringbooks

Free coloring pages on our Facebook page!

Enjoy these preview pages from some of our other coloring books!

Christmas Cats Coloring Book

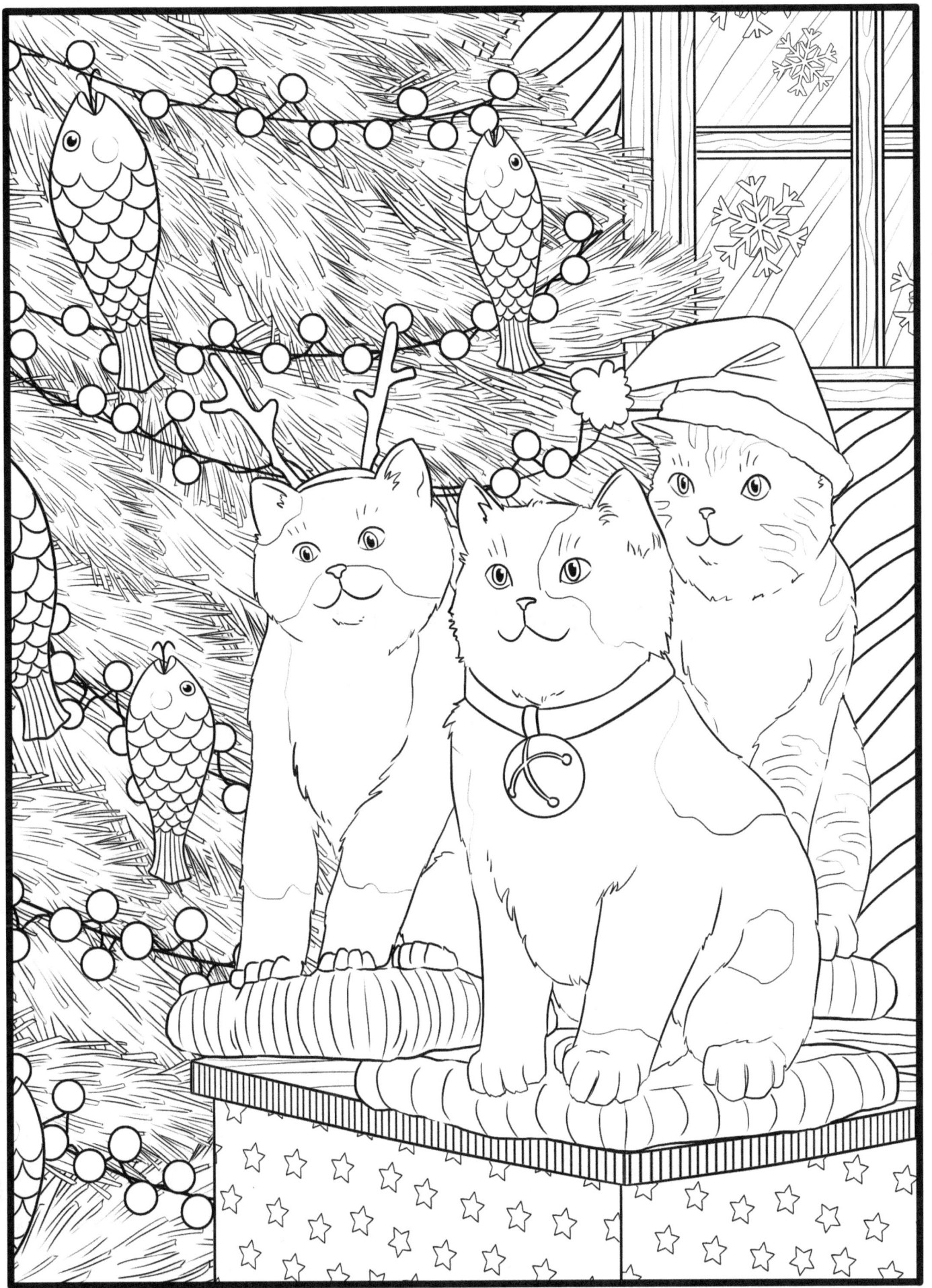

The Pug Lovers Coloring Book

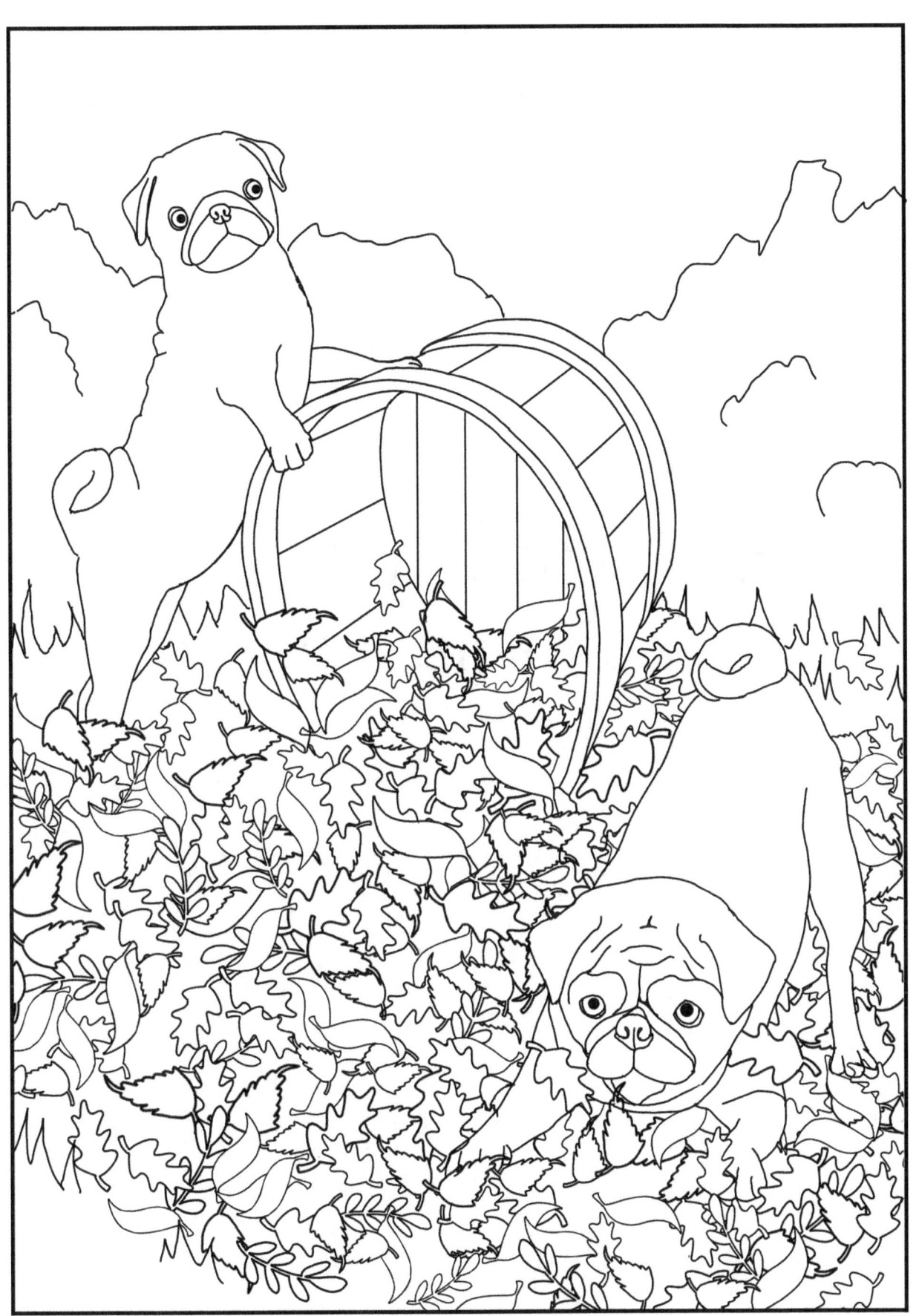

The Dachshund Lovers Coloring Book

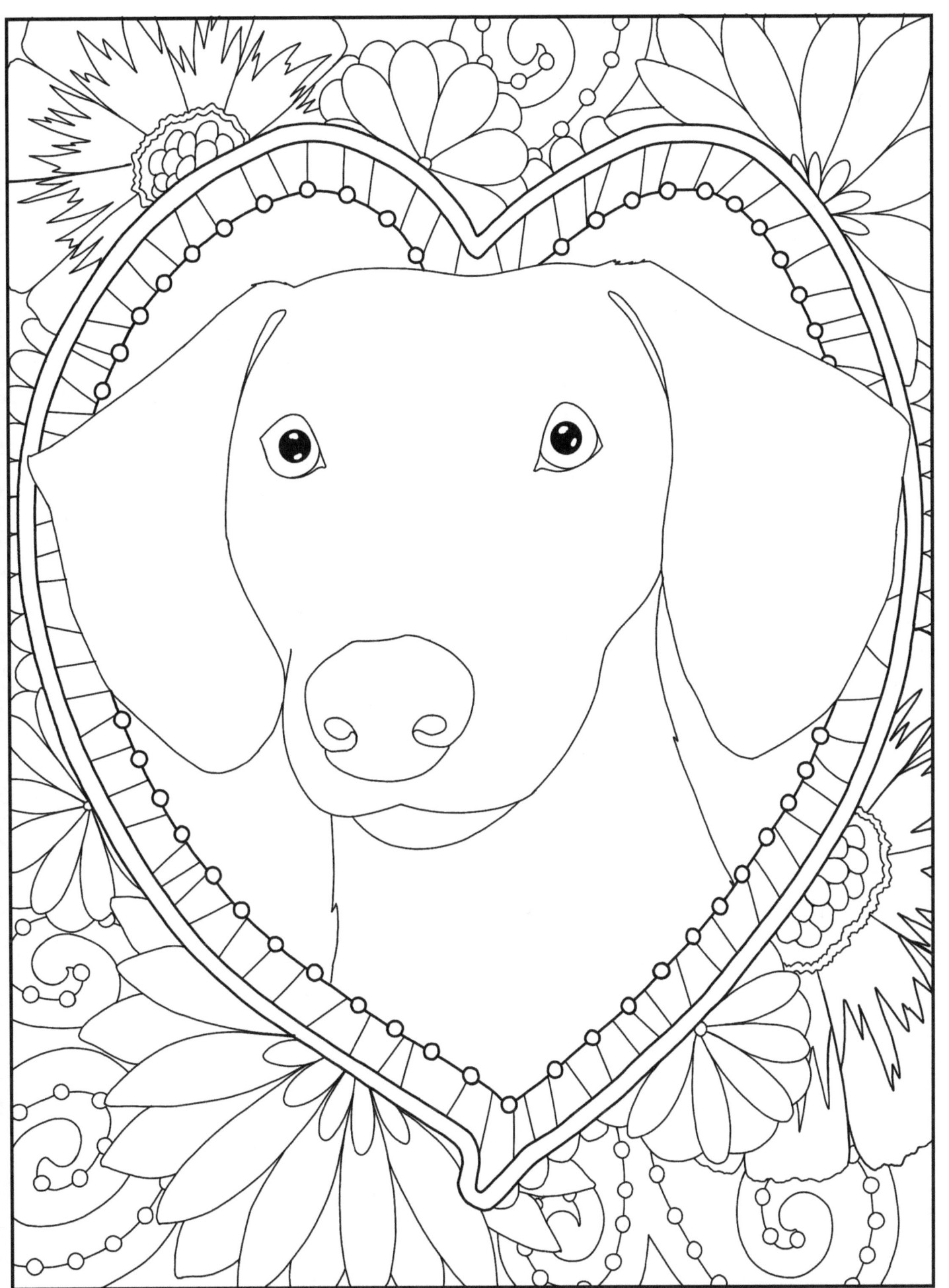

www.ingramcontent.com/pod-product-compliance
Lightning Source LLC
Chambersburg PA
CBHW060004230526
45472CB00008B/1936